How Artists See
FAMILIES
Mother Father Sister Brother

Colleen Carroll

ABBEVILLE KIDS

A DIVISION OF ABBEVILLE PUBLISHING GROUP

New York London Paris

*"Painters understand nature and love her
and teach us to see her."*

—VINCENT VAN GOGH

––––––––

This book is dedicated, with my deepest love, to Natalie Rose.
Thank you for bringing our family such immeasurable joy.

I'd like to thank the many people who helped make this book
happen, especially Jackie Decter, Ed Decter, Colleen Mohyde,
and as always, my husband, Mitch Semel.

— COLLEEN CARROLL

JACKET FRONT: Carmen Lomas Garza, *Sandia
(Watermelon)*, 1986 (see also pages 18 and 19).
JACKET BACK, CLOCKWISE FROM UPPER LEFT:
Kikugawa Eizan, *Mother Carrying Her Baby Son on
Her Back*, c. 1810 (see also pages 6 and 7); Winslow
Homer, *Crossing the Pasture*, 1872 (see also pages
34 and 35); John Singer Sargent, *Carnation, Lily,
Lily, Rose*, 1885–86 (see also pages 26 and 27).

EDITOR: Jacqueline Decter
DESIGNER: Jordana Abrams
ART DIRECTOR: Patricia Fabricant
PRODUCTION EDITOR: Meredith Wolf
PRODUCTION MANAGER: Lou Bilka

Abbeville Publishing Group, 22 Cortlandt Street,
New York, N.Y. 10007. The text of this book was
set in Stempel Schneidler. Printed in Hong Kong.

First library edition
10 9 8 7 6 5 4 3 2 1

Library of Congress Cataloging-in-Publication Data
Carroll, Colleen.
 Families : mother, father, sister, brother /
Colleen Carroll.
 p. cm. — (How artists see,
 ISSN 1083-821X)
 Includes bibliographical references.
 Summary: Examines how families have been
depicted in works of art from different time
periods and places.
 ISBN 0-7892-0188-7,
 0-7982-0671-4 (library edition)
 1. Family in art—Juvenile literature.
2. Juvenile literature. [1. Family in art. 2. Art
appreciation.] I. Title. II. Series: Carroll,
Colleen. How artists see.
N8217.F27C37 1997
707.9′4930685—dc21 97-21325

CONTENTS

MOTHER 4

FATHER 12

SISTER 20

BROTHER 28

Note to Parents and Teachers 36

Artists' Biographies 38

Suggestions for Further Reading 43

Where to See the Artists' Work 45

Credits 48

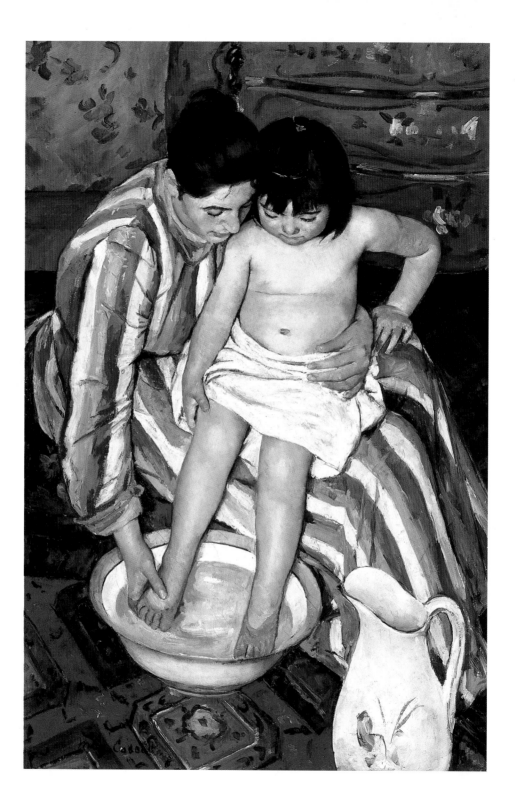

4

THE BATH

by Mary Cassatt

The world, as you know, is made up of many different cultures. Yet all cultures have at least one thing in common—the family. What is a family? The answer depends on whom you ask, because each person has his or her own ideas and feelings about what it means to be a family. For thousands of years artists have been answering that question, too. Just as no two families are exactly alike, no two artists show families in exactly the same way. In this book you'll discover some examples of how artists see families. Some of the families you meet just might remind you of your own.

In this oil painting the artist captures a very tender and private moment. A mother gently bathes her daughter, who watches with rapt attention. How would you describe the feelings they have for each other? The artist used many patterns to make the picture lively and interesting to look at. How many different patterns can you find?

MOTHER CARRYING HER BABY SON ON HER BACK

by Kikugawa Eizan

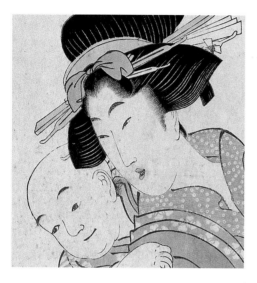

In this beautiful picture a mother and her baby son share a moment of pleasant surprise as they gaze into a pool of water. What do they see? If you noticed their reflections, you have a very keen eye. (If you don't see them, try turning the picture on its side.)

The baby stares at his image with curious fascination. What do you suppose he is thinking?

6

Line is very important in this woodcut. Trace your finger over all the lines you see. Most of them are curved, such as the ones on the mother's flowing kimono. These lines make her look slender and graceful. What words would you use to describe this young mother? As she arches her back toward the water, her whole body forms another curve. Move your finger along the right side of her body to follow its serpentine path.

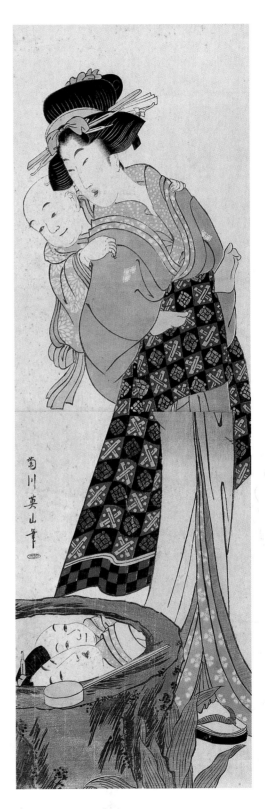

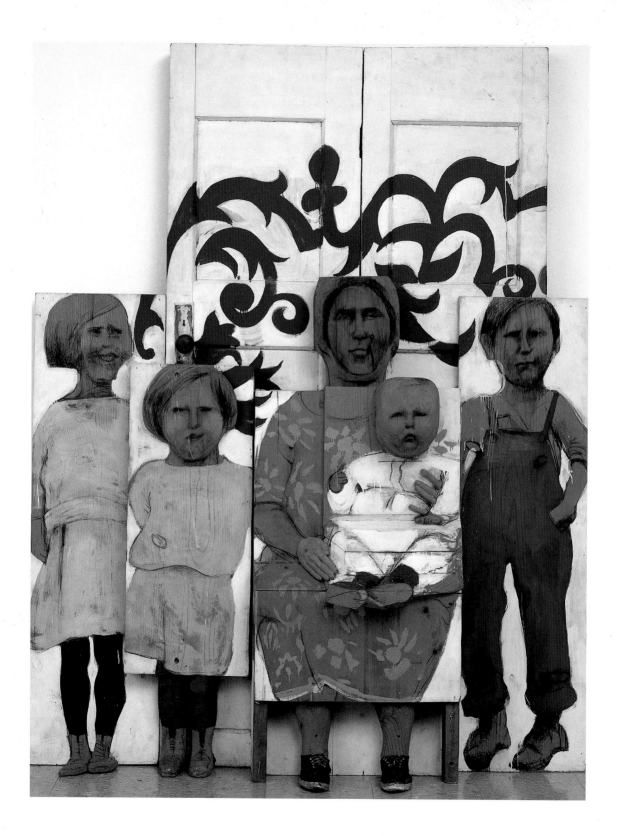

THE FAMILY

by Marisol

Not all artists use traditional materials, such as paint and clay. This mixed-media artwork is made from many different kinds of materials. Some you might expect to see, like wood, while others might surprise you. How many materials can you find? Painted on the door behind the people is a black decorative pattern. What do you think it is supposed to be?

In this portrait of a mother and her four children, the family members pose side by side. All wear serious facial expressions except for the older sister, who shows just the faintest hint of a smile. The baby looks different from the others. Sculpted from wood, his face is round and pudgy, just like a real baby's. What other three-dimensional forms can you find?

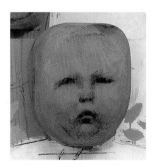

9

MOTHER

MADONNA OF THE CLOUDS

by Donatello

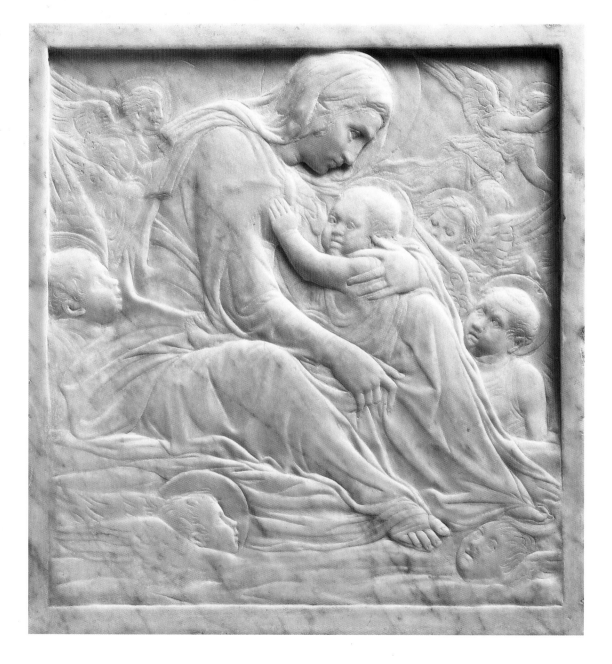

Have you ever wondered what it would be like to rest on a cloud? In this marble relief sculpture, the holy mother and child seem to float on a soft cushion of sky. The Madonna grasps her baby protectively, but her gaze is not upon him. Instead, she looks toward the clouds. What do you think she is looking at?

Even though this sculpture is carved in stone, it has the appearance of a drawing. Because the marble isn't deeply carved, it looks light and delicate, like a sketch. Of all the figures, the Madonna's head is carved the most deeply. Why do you think the artist chose to carve her this way? Angels flutter about and fill the sky with lighthearted activity. How many angels can you find?

FIRST STEPS

by Vincent van Gogh

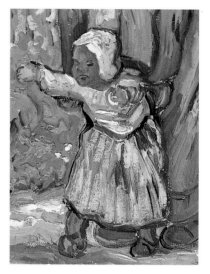

This picture captures the thrilling moment when a baby begins to take her first steps. The baby's mother supports the child while the father waits a few feet away with outstretched arms. The baby mirrors her father's movement, stretching her arms toward his. Soon the mother will let go and allow the baby to walk on her own. Do you think she will make it all the way to her father without falling? What do you think each parent feels at this exact moment?

The artist used thick brush strokes that wiggle and curve all over the picture. How do the brush strokes help you feel the excitement of the event?

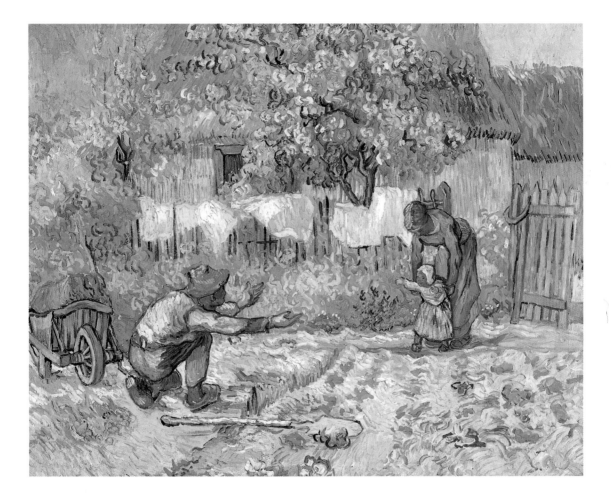

13

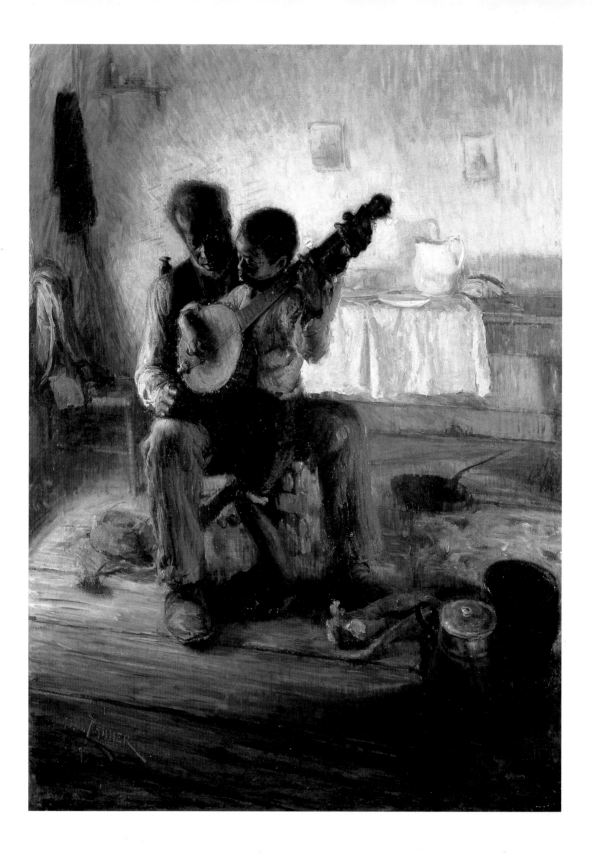

THE BANJO LESSON

Henry Ossawa Tanner

Like memories, traditions are an important part of a family's history. In this picture, a father (or perhaps a grandfather) passes along his knowledge of music to his young son. Holding the neck of the banjo at the proper angle, he watches patiently as the boy tries to finger the right chords and pluck the metal strings.

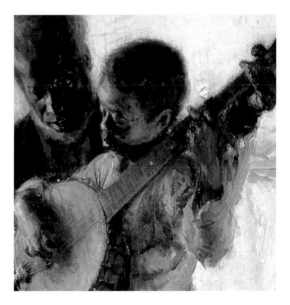

How do you think the father feels to be sharing this special family tradition with his son? In what ways does the artist express the feelings they have for each other?

In this simple, dimly lit room, you cannot see the pair very clearly. The back of the room is lit by a pinkish yellow glow, perhaps from a candle or kerosene lamp on the wooden table. Although father and son are mostly in shadow, a warm orange light falls on the boy, highlighting his focused expression and the fingers of his left hand. Where do you think this light is coming from?

15

THE SARGENT FAMILY

Artist Unknown
(American, 19th century)

Here is a lively portrait of an American family that lived nearly two hundred years ago. The father has just come home from work or perhaps from a journey.

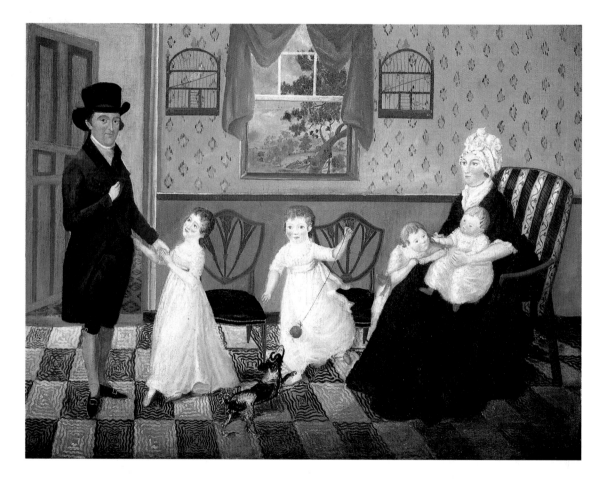

16

His placement in the open doorway was a deliberate choice made by the painter. How does the doorway make the father stand out more than the other family members? In what other ways is your eye drawn to him?

Looking at the room in which the Sargent family is gathered, what details do you see that help you understand what it was like to live here? Take a look at the view outside the window. Where do you think they live?

SANDIA (WATERMELON)

by Carmen Lomas Garza

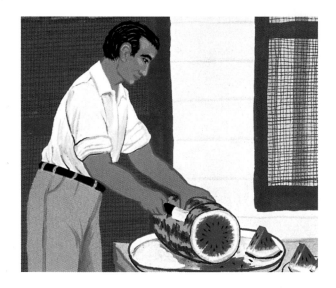

Some of the most special family moments are spent at home. The family members in this picture are enjoying juicy slices of watermelon. Although it's nighttime, the porch is so brightly lit that it seems like midday. Point to all the places where light comes from in the picture.

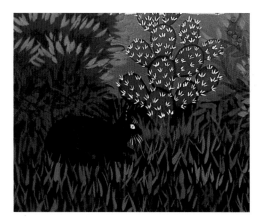

How many did you find? Because the picture is so full of light, it's easy to notice many tiny details, such as the prickly white cactus needles and the watermelon seeds lying about the porch. What other details do you see?

18

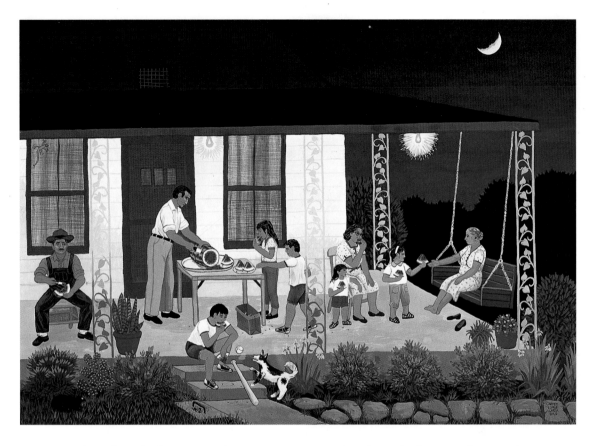

Like the father in *The Sargent Family,* this father is framed
by the rectangular doorway. In what other ways does the
artist draw your attention to him? All the family members
are absorbed in this delicious activity. Close your eyes
and try to imagine the sounds you might hear on this
summer evening. What might they be?

TAR BEACH

by Faith Ringgold

This story quilt is based on the artist's memories of childhood, when she would spend warm summer evenings with her family atop the tarpaper-covered roof of their apartment building. She included many details, such as the table laid out with a delicious summer meal and New York City's glittering skyline, that help you understand why this evening, and others like it, live on in her memory. What other details do you see? The artist

painted herself lying on a mattress next to her brother. She also appears in another part of the picture. Where is she? What do you think she is doing?

Although this artwork is a painting, it's also a quilt. Surrounding the painted center are many pieces of colorful fabric. If you look closely at the white bands at the top and bottom, you'll see the artist's written thoughts and feelings about these special memories. What activities does your family do that may become fond memories for you?

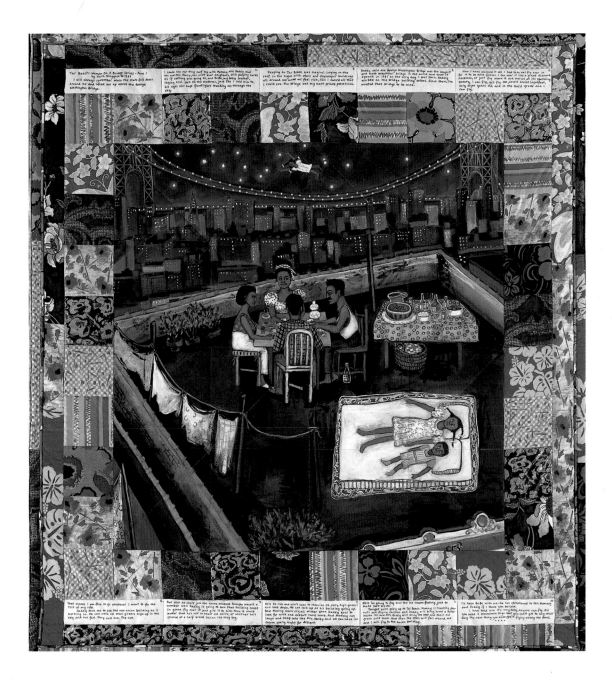

THREE SISTERS PLAYING CHESS

by Sofonisba Anguissola

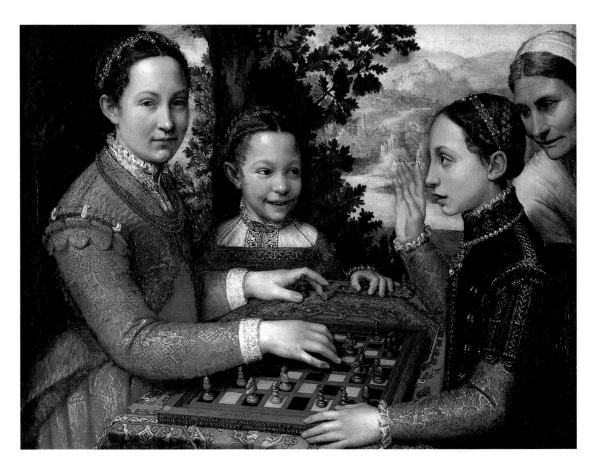

Even though the three sisters in this painting lived over four hundred years ago, they could just as easily be any trio of sisters you might see today, passing their time playing a board game. The oldest sister takes her turn

and stares out at someone in the distance. (Maybe she is looking at you!) Her younger sister and opponent holds her hand at the ready, anxious to make her next move. The youngest girl stands between them, a mischievous smile on her face. What might she be thinking to produce such a grin?

The sisters and their chaperone seem so close that you could almost pull up a chair and join the fun, maybe even play the next game. What do you see behind them? Do you think the girls are indoors or outside?

BRETON GIRLS DANCING,
PONT-AVEN

by Paul Gauguin

Here you see three young girls doing a folk dance called a
round. Although they dance in a circle, their bodies form
a triangle. Starting with the girl on the left, trace your
finger from her head to the head of the girl in the center,

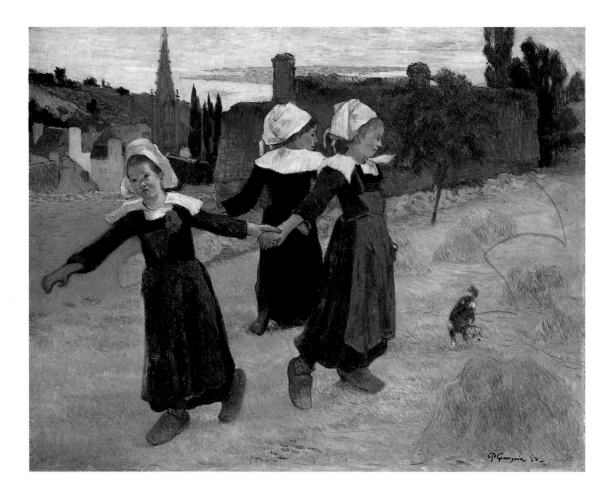

as if you were connecting dots. Then, move your finger to the girl on the right and return to the starting point. You will see that your finger has traced out a triangular shape. Triangles appear in other parts of the picture, too. How many can you find?

The girls link hands as they dance among a group of small haystacks. Do you think their dance is energetic and fast-paced or moves to a slower beat? A puppy sniffs the ground and seems to wag his tail in time with the rhythm. Imagine this dance and clap out the beat with your hands.

CARNATION, LILY, LILY, ROSE

by John Singer Sargent

This beautiful picture invites you into a lush garden at dusk, just as two sisters light a pair of Japanese lanterns. The illuminated lanterns glow like magical beehives. How many lanterns can you find? The light they shed makes the flowers stand out vividly against the dark green foliage, highlighting the delicate arch that frames the sisters as they go about their work. Trace your finger around the arch of flowers.

The lanterns cast a soft pink light on the girls' faces and on the petal-like ruffles of their matching white dresses. Standing amid the pink and white blossoms of this twilight garden, the sisters look almost like flowers themselves. Try to imagine the fragrance of this summer evening. What does it smell like to you?

26

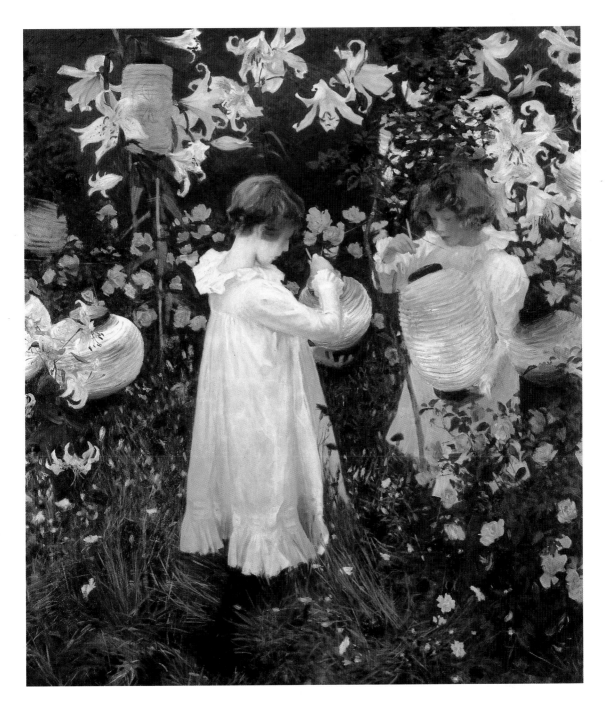

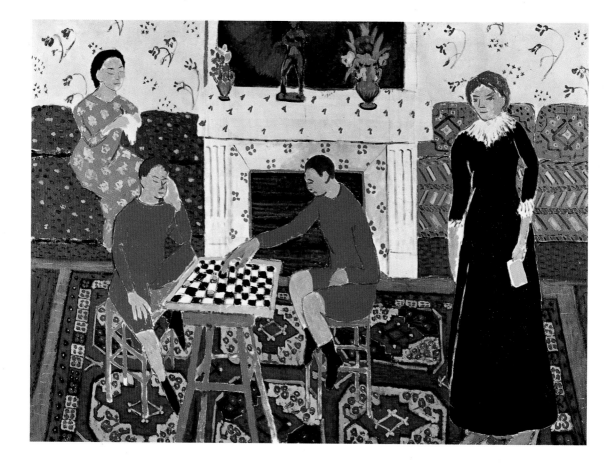

THE PAINTER'S FAMILY

by Henri Matisse

It's easy to tell who the brothers are in this picture. Dressed in bright red playclothes, the boys are engrossed in a game of checkers. The one on the left rests his head in his hand as he observes his brother making a move. Perhaps he is formulating a strategy. Look back at *Three Sisters Playing Chess.* Which family seems to be having more fun?

You've probably noticed the colorful patterns that decorate this room. How many can you find? The artist dressed the boys in solid, red clothing so they would stand out clearly against all the different patterns. Look back through the book. What other artist uses pattern in a similar way?

THE BIGLIN BROTHERS RACING

by Thomas Eakins

The race has officially begun! Here you see two adult brothers competing as a team in a regatta, or boat race. The artist has captured the moment just before the oars slice through the water and propel the boat forward. The rear man watches his brother's oar carefully. Why do you think he does this? So far they are in the lead. Where are their opponents?

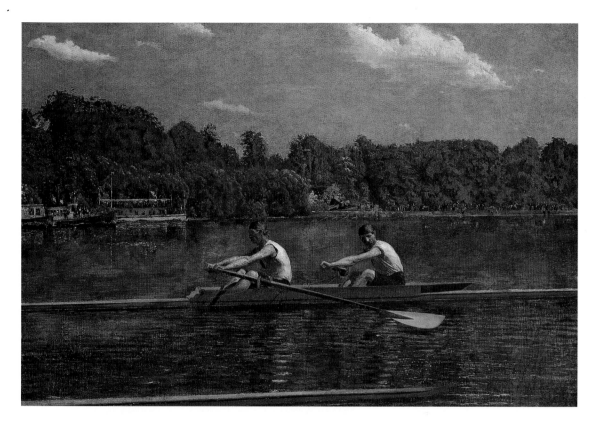

The Biglin brothers couldn't have picked a more perfect day for a race. There's barely a cloud in the sky, and the sun fills the scene with warmth and light. How can you tell the sun is shining? Point to all the places in the picture where you see reflected sunlight.

TOMBS OF GIULIANO AND LORENZO DE' MEDICI

Michelangelo

For nearly five hundred years these two brothers have been sitting just as you see them here. Of course they have, you're probably thinking, they're statues! The artist carved them not as they appeared in life, but as he wanted future generations to see them: young, handsome, and strong, sitting above their tombs like kings on thrones. Even the mythological figures that rest on their tombs seem almost superhuman. In reality, both brothers had bearded faces, yet here they are clean shaven. Although they were not soldiers,

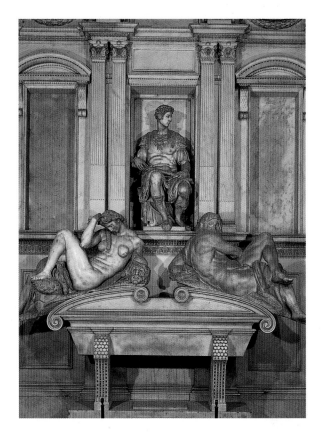

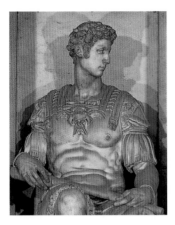

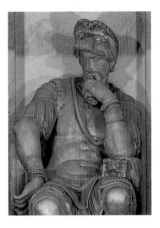

the artist dressed them in military costumes. Giuliano sits up straight and looks over his left shoulder, while his brother Lorenzo lowers his gaze in quiet thought. What do these different poses tell you about their personalities?

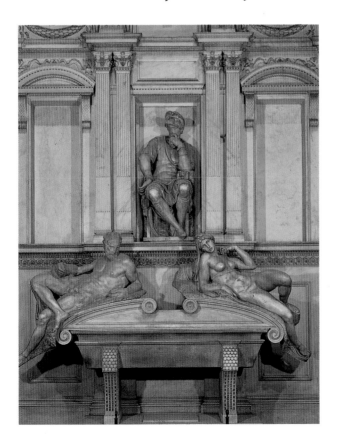

Carved from marble, these massive structures seem to have outgrown their tight niches. Their feet even hang over the edge of the marble slabs of floor. Why do you think the artist placed his oversize statues in such small spaces?

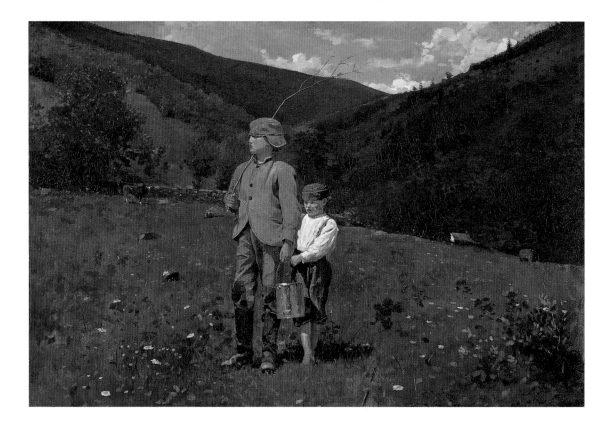

34

CROSSING THE PASTURE

by Winslow Homer

What would you do if you encountered a bull in a wide, open field? That's exactly what is happening to the two brothers you see in this picture. Examine the background and you'll find the bull staring in their direction. They

stand as still as statues, perhaps hoping to go unnoticed by the animal. The older brother seems calm and ready to protect his little brother. Look at the younger boy's expression. What do you think he is feeling? Do you think they'll make it back to the barn safely?

As you have seen, artists have many ways of expressing what it means to be a family. Today more than ever, families come in all shapes, sizes, and combinations. And just as every artist has his or her own style, every family has its own special qualities. So with that in mind, try making an artwork that celebrates your own family— in your own, unique style.

NOTE TO PARENTS
AND TEACHERS

As an elementary school teacher I had the opportunity to show my students many examples of great art. I was always amazed by their enthusiastic responses to the colors, shapes, subjects, and fascinating stories of the artists' lives. It wasn't uncommon for us to spend an entire class period looking at and talking about just one work of art. By asking challenging questions, I prompted the children to examine and think very carefully about the art, and then quite naturally they would begin to ask all sorts of interesting questions of their own. These experiences inspired me to write this book and the other volumes in the *How Artists See* series.

How Artists See is designed to teach children about the world by looking at art, and about art by looking at the world through the eyes of great artists. The books encourage children to look critically, answer—and ask—thought-provoking questions, and form an appreciation and understanding of an artist's vision. Each book is devoted to a single subject so that children can see how different artists have approached and treated the same theme and begin to understand the importance of individual style.

Because I believe that children learn most successfully in an atmosphere of exploration and discovery, I've included questions that encourage them to formulate ideas and responses for themselves.

And because people's reactions to art are based on their own personal aesthetic, most of the questions are open-ended and have more than one answer. If you're reading aloud to your children or students, give them ample time to look at each work and form their own opinions; it certainly is not necessary to read the whole book in one sitting. Like a good book or movie, art can be enjoyed over and over again, each time with the possibility of revealing something that wasn't seen before.

You may notice that dates and other historical information are not included in the main text. I purposely omitted this information in order to focus on the art and those aspects of the world it illustrates. For children who want to learn more about the artists whose works appear in the book, short biographies are provided at the end, along with suggestions for further reading and a list of museums where you can see additional works by each artist.

After reading *How Artists See Families,* children can do a wide variety of related activities to extend and reinforce all that they've learned. In addition to the simple activities I've suggested throughout the main text, they can draw or paint a family portrait, construct a family tree, or plan and cook a special family meal. Since the examples shown here are just a tiny fraction of the great works of art that feature families as their subject, children can go on a scavenger hunt through museums and the many art books in your local library to find other images of families.

I hope that you and your children or students will enjoy reading and rereading this book and, by looking at many styles of art, discover how artists share with us their unique ways of seeing and depicting our world.

ARTISTS' BIOGRAPHIES

(in order of appearance)

If you'd like to know more about the artists in this book, here's some information to get you started:

MARY CASSATT
(1844–1926), *pp. 4–5*

Born into a wealthy family, the American painter Mary Cassatt (pronounced *kuh-SAHT*) traveled throughout Europe when she was young. On these trips she was exposed to the works of the European masters and decided to become a professional artist. She studied art at the Pennsylvania Academy of Fine Arts in Philadelphia and later in Italy and Paris, where she moved in 1874. There she met the Impressionist artist Edgar Degas. They quickly became friends and soon Cassatt began painting in a style similar to Degas's and the other Impressionists', and even exhibited her own work with them on many occasions. She is best known for her portraits of mothers with their children and of women doing everyday activities, such as sealing a letter or adjusting a veil. Besides being an accomplished painter she was also a printmaker, and many of her prints were influenced by the Japanese woodcuts so popular in late-nineteenth-century Paris (see *Mother Carrying Her Baby Son on Her Back*).

KIKUGAWA EIZAN
(1787–1867), *pp. 6–7*

The son of a craftsman, Kikugawa Eizan (pronounced *ay-zan*) was born in Edo, the present-day city of Tokyo, Japan. His father made artificial flowers for a living and was the first to teach his son the art of painting. Eizan studied and mastered the style of Japanese painting known as ukiyo-e, which was popular from 1603 to 1867. *Ukiyo-e* means "the floating world," and art from this period depicts happiness and the pleasures of daily life. As a young artist Eizan became popular for his prints of beautiful, slender women in standing poses, such as the one seen here. His art and that of other ukiyo-e artists influenced the American painter and printmaker Mary Cassatt and the French Impressionists (see *The Bath*).

MARISOL (BORN 1930), *pp. 8–9*

This very international artist was born in Paris, France, to Venezuelan parents, and later moved to New York City. In New York Marisol (pronounced *MA-ri-sall*) studied at the Art Students League and the New School, and became part of the Pop Art movement of the early 1960s. The Pop artists drew their subjects from popular culture, such as movie and television personalities, commercial products, and comic books. Because Marisol's sculptures often included the faces of recognizable people, her early work is considered Pop Art. She is best known for her sculptures. Most are carved from wood but include an assemblage of many other materials and often incorporate her self-portrait. In honor of her artistic achievements, Marisol received the Gold Medal of the National Arts Club in 1994.

DONATELLO (1386–1466), *pp. 10–11*

Although he was born Donato di Niccolò Bardi, the world knows this Italian Renaissance artist simply as Donatello (pronounced *doh-nah-TEL-loe*). As a boy he apprenticed in the workshop of the sculptor Lorenzo Ghiberti. Eventually he had his own workshop, in which he trained young artists and produced works of astonishing realism, emotion, and drama. Best known for his reliefs (like the one seen here), Donatello was an extremely versatile artist who also created freestanding sculptures, tombs, pulpits, and even equestrian monuments. He worked with many different materials, including marble, bronze, wood, terra-cotta, and stucco. Among his many accomplishments, Donatello is credited with creating the first freestanding sculpture since ancient times. His work inspired and influenced many artists, including Michelangelo (see *Tombs of Giuliano and Lorenzo de' Medici*).

VINCENT VAN GOGH (1853–1890), *pp. 12–15*

Even though this Dutch artist painted for only seven years, he left behind hundreds of paintings and drawings that are among the world's most famous and beloved artworks. Vincent van Gogh (pronounced *van-GO*) planned to become a minister, like his father, but discovered his passion for art after moving to France. Known for deep, vivid colors and thick brush strokes, van Gogh liked to paint outdoors in full sunlight, and often painted two or more pictures a day. His brother Theo worked for an art dealer, and sent Vincent paints and canvases so he could spend most of his time painting. The artist's great energy can be seen in his many portraits, still lifes, and landscapes, all of which are bursting with movement and emotion. Even though people didn't appreciate van Gogh's art during his lifetime (he rarely sold a painting), today he is thought to be one of the greatest artists who ever lived.

HENRY OSSAWA TANNER (1859–1937), *pp. 14–15*

American painter Henry Ossawa Tanner was born in Pittsburgh, Pennsylvania, to parents who valued education and culture. His mother, a former slave, was a schoolteacher; his father, a minister and crusader for social justice. Tanner studied under the American realist painter Thomas Eakins (see *The Biglin Brothers Racing*), painted for a time in the United States, and at age thirty-two moved to France to escape the racism that he faced at home. As he put it, he could not "fight prejudice and paint at the same time." Best known for landscapes and biblical scenes, Tanner was the most successful African-American artist of his generation. In 1996 his painting *Sand Dunes at Sunset, Atlantic City* became the first artwork by an African-American artist to be represented in the White House Collection.

AMERICAN FOLK ART PORTRAITURE (19TH CENTURY), *pp. 16–17*

Not long after the American War for Independence and before the invention of the camera, the professional portrait painter enjoyed a period of success and

popularity. As the growing middle class began to have both time and money to spend, more and more people hired portrait artists to record their likeness for future generations. Many examples of American portraiture survive, some by major artists, but most by unknowns. Because most portrait painters had little or no training, their work is considered a form of folk art. Some common features of American folk art portraiture are realistic facial likenesses, attention to detail, rich colors, and people in stiff poses. These untrained artists could not easily depict rounded forms, so their pictures have a flat appearance. Once cameras became widely available, most people opted for the cheaper, faster method of capturing their likeness, forcing many portrait artists to change with the times or go out of business.

CARMEN LOMAS GARZA
(BORN 1948), *pp. 18–19*

"I wanted to depict in fine art form all the things of our culture that are important or beautiful or very moving." The Mexican-American artist Carmen Lomas Garza does indeed capture and celebrate her Latina heritage in paintings that depict memories of her childhood in a small town near the Mexican border. Born in Kingsville, Texas, Lomas Garza knew as a teenager that she wanted to become an artist. After getting master's degrees in art and education, she worked for a short time in an art gallery before becoming a full-time artist. She is also an accomplished printmaker and the author of three books.

FAITH RINGGOLD
(BORN 1934), *pp. 20–21*

American artist and writer Faith Ringgold (pronounced RIN-*gold*) was born in Harlem, an area of New York City. Her mother, who was a fashion designer, seamstress, and quilt maker, taught her young daughter how to sew and encouraged her artistic interests. Ringgold attended college and eventually earned a teaching certificate and a master's degree in the fine arts. While in college she began to explore African-American themes and subjects, and would mix her paints to create realistic skin tones. For many years she taught art in the New York City school system, and at the same time worked to develop her own individual style. Best known for her story quilts, Ringgold combines painting, sewing, and writing to create art that is uniquely her own.

SOFONISBA ANGUISSOLA
(C. 1532–1625), *pp. 22–23*

During Italian artist Sofonisba Anguissola's (pronounced *ahn-GWEE-soe-luh*) lifetime, most women received no education and were not encouraged to have careers outside the home. Anguissola was an "exception to the rule." Her father insisted that his five daughters learn Latin, play music, and paint. Because of the support and opportunities her family gave her, she became a professional painter. She is well known for the many portraits she painted when she served as a painter to the Spanish court. But her most important works are paintings of people in warm, domestic settings going about their everyday activities. One art critic coined a name for this type of subject

matter: "the conversation piece." This woman who was so far ahead of her time also painted many self-portraits, a genre that would be made popular by many artists who came after her.

PAUL GAUGUIN
(1848–1903), *pp. 24–25*

The French Post-Impressionist artist Paul Gauguin (pronounced *go-GAN*) didn't begin his career as a painter until he was in his twenties. Before that he was a successful businessman who earned a good living to support his wife and family. As an artist he never experienced the same financial success. His favorite subjects were simple people and their religious and superstitious beliefs. He painted with pure, vivid color, and often changed the real colors of things to create a mood or feeling. After working in France for many years, he decided to leave the "civilization" of Europe for a simpler life on the Pacific island of Tahiti, where he began to paint pictures of the native people and the environment. He returned briefly to France to exhibit his new work. When he went back to Tahiti he became very ill and died poor and alone. Although his life as an artist was marked by difficulty, the work he left behind went on to influence many generations of twentieth-century artists.

JOHN SINGER SARGENT
(1856–1925), *pp. 26–27*

The American portrait painter and watercolorist John Singer Sargent was born in Italy to American parents, and traveled with them throughout Europe during his childhood. He studied art in Paris before moving to London, where he became a successful portrait painter of wealthy and important people. He applied paint in strong, free brush strokes and often spent months working on a single portrait to get the details just right. Toward the end of his life he grew tired of painting portraits and switched to painting beautiful watercolors of the outdoors.

HENRI MATISSE
(1869–1954), *pp. 28–29*

When Henri Matisse (pronounced *mah-TIECE*), now considered a "father of modern art," was twenty years old, he was studying to be a lawyer. To pass the time while recovering from an illness, he began to draw. A year later he left his law studies to pursue a career in painting. During his long and productive life, Matisse worked in many different styles. Early in his career he was the leader of a group of painters called the Fauves, which in French means "wild beasts." The Fauves got their name because they used color in bold ways. In one of Matisse's most well-known portraits, he painted his wife's face bright green! His favorite subjects included dancers, still lifes, and interiors of colorful rooms. Late in his life, when he could no longer paint, Matisse made collages out of brightly colored paper. These "cut-outs" became some of his most innovative and popular work.

THOMAS EAKINS
(1844–1916), *pp. 30–31*

American painter, photographer, and teacher Thomas Eakins (pronounced *AY-kinz*) was educated in the United States and France. After another six years of study in Spain, he returned to

41

his home state of Pennsylvania to paint and teach art. His paintings of outdoor scenes, especially of boat races, seem as realistic as photographs yet sensitively capture light and the details of nature. Eakins is well known for his portraits, which reveal the character and personality of his sitters, and for his genre scenes, which show people engaged in daily activities. One such picture, *The Gross Clinic,* shows a doctor instructing a group of medical students in a surgical procedure. The scene was so realistic that people were offended by the painting. Always ahead of his time and not always accepted by the public, Thomas Eakins was recognized for his artistic vision and accomplishments only toward the end of his life.

MICHELANGELO BUONARROTI (1475–1564), *pp. 32–33*

Michelangelo Buonarroti, commonly known by his first name, was perhaps the most remarkable and gifted artist who ever lived. Born in Florence, Italy, he became an artist's apprentice at thirteen. One year later the teenager was invited to live in the palace of Lorenzo de' Medici, a wealthy businessman and patron of the arts. In his early twenties he began work on a sculpture that he claimed would be "the most beautiful work in marble which exists today in Rome." When he finished the *Pietà,* a beautiful statue of the Virgin Mary holding the dead body of Jesus on her lap, Michelangelo became an overnight star. He believed that with his chisel he could "release" his sculptures from their stone prisons. Because he accepted so

many difficult projects during his career, he left many works unfinished, and it is possible to see some of these sculptures still partially trapped inside the blocks of stone. Although he preferred sculpting to painting, he accepted Pope Julius II's offer to paint the ceiling of the Sistine Chapel with scenes from the Bible. After only four years, working almost entirely alone, he completed his masterpiece—one of the greatest works of art ever made. All of this master's art depicts human beings, both men and women, as muscular and powerful; Michelangelo believed that physical strength expressed the strength of the soul.

WINSLOW HOMER (1836–1910), *pp. 34–35*

American artist Winslow Homer was born in New England but moved to New York City as a young man to become an illustrator. When the Civil War broke out, Homer was hired by a popular magazine to paint pictures of the front. After the war he continued making illustrations but spent more and more time painting scenes from everyday life in the realistic style he is famous for. In 1881 he traveled to England, where he lived in a seaside fishing village, an experience that took his art in a new direction. When he returned to America he began to paint—in both watercolors and oils—rugged pictures of the sea. He liked to use watercolor paints to sketch scenes from nature, especially the seaside, and he used some of these watercolor studies as ideas for his oil paintings.

SUGGESTIONS FOR FURTHER READING

The following children's titles are excellent sources for learning more about the artists profiled in this book:

FOR EARLY READERS (AGES 4–7)

Anholt, Laurence. *Camille and the Sunflowers: A Story About Vincent van Gogh.* Hauppauge, New York: Barron's, 1994.
Camille Roulin, the young boy whose family befriended van Gogh, describes his experiences with the great Dutch artist while he lived and painted in Arles, France.

Venezia, Mike. *Gauguin.* Getting to Know the World's Greatest Artists series. Chicago: Children's Press, 1994.
This easy-to-read biography combines color reproductions and humorous illustrations to capture the personality and talent of the famous twentieth-century artist. Included in this series are *Henri Matisse* and *Mary Cassatt,* also by Mike Venezia.

FOR INTERMEDIATE READERS (AGES 8–10)

Hart, Tony. *Michelangelo.* Illustrated by Susan Hellard. Famous Children series. Hauppauge, New York: Barron's Juveniles, 1994.
This cute book introduces young readers to the Renaissance master when he was a budding artist.

Lomas Garza, Carmen. *Family Pictures.* San Francisco: Childrens Book Press, 1990.
Based on the artist's experience growing up in a traditional Hispanic community, this book is illustrated with reproductions of Lomas Garza's paintings. Winner of the American Library Association's Notable Book award.

Lomas Garza, Carmen. *In My Family = En Mi Familia.* San Francisco: Children's Book Press, 1996.
Like Family Pictures, this follow-up book shares the artist's memories of life in a Texas town near the Mexican border. The bilingual text is written in English and Spanish and is illustrated with the artist's paintings.

Mason, Antony. *Matisse.* Famous Artists series. Hauppauge, New York: Barron's, 1995.
This wonderful reference book provides a wealth of information about the life and work of the French painter who helped shape the course of twentieth-century art. Another title in this series is devoted to the Dutch painter Vincent van Gogh.

Raboff, Ernest. *Albrecht Dürer.* Art for Children series. New York: HarperCollins, 1988.
This informative book describes the life, times, and style of this German Renaissance artist. Other titles in this series include: *Vincent van Gogh, Henri Matisse,* and *Michelangelo Buonarroti.*

Ringgold, Faith. *Tar Beach.* New York: Crown Publishers, 1991.
Winner of the prestigious Caldecott Medal for outstanding picture books, the artist shares her memories of Tar Beach, the New York City rooftop that she depicted in her famous story quilt.

FOR ADVANCED READERS (AGES 11+)

Beneduce, Ann Keay. *A Weekend with Winslow Homer.* New York: Rizzoli, 1993.
This informative and clever book takes you back in time to meet the American painter, who tells you of his life and work. Also in this series: *A Weekend with van Gogh* by Rosabianca Skira-Venturi.

Greenfield, Howard. *Paul Gauguin.* First Impressions series. New York: Harry N. Abrams, 1993.
This biography gives a thorough introduction to the painter's interesting life and work.

Milande, Véronique. *Michelangelo and His Times.* W5 series. New York: Henry Holt and Company, 1996.
Clever text, beautiful full-color photographs, and illustrations take readers through the many fascinating stages of the Renaissance master's long and productive life.

Montana-Turner, Robyn. *Mary Cassatt.* Portraits of Women Artists for Children series. Boston: Little Brown and Company, 1994.
The fascinating life of this unique American artist is enriched by many wonderful examples of her paintings. Another title in this series is *Faith Ringgold,* also by Robyn Montana-Turner.

Mühlberger, Richard. *What Makes a Cassatt a Cassatt.* New York: The Metropolitan Museum of Art and Viking, 1994.
The life and work of the American painter is explored in an examination that shows children how to recognize the artist's unique style.

44

WHERE TO SEE THE ARTISTS' WORK

AMERICAN FOLK ART PORTRAITURE, 19TH CENTURY

- The Metropolitan Museum of Art, New York
- Museum of American Folk Art, New York
- Museum of Fine Arts, Boston
- National Museum of American Art, Smithsonian Institution, Washington, D.C.
- Newark Museum, New Jersey
- Abby Aldrich Rockefeller Folk Art Collection, Williamsburg, Virginia
- Shelburne Museum, Shelburne, Vermont

SOFONISBA ANGUISSOLA

- Kunsthistorisches Museum, Vienna
- Milwaukee Art Center, Milwaukee, Wisconsin
- Museo e Gallerie Nazionali di Capodimonte, Naples, Italy
- Museum of Fine Arts, Boston
- Muzeum Narodowe, Poznan, Poland
- National Museum of Women in the Arts, Washington, D.C.
- Prado, Madrid
- http://libweb.sonoma.edu/special/waa/ArtistList/biolistl.html#angui

MICHELANGELO BUONARROTI

- Accademia, Florence
- Bargello, Florence
- Casa Buonarroti, Florence
- Louvre, Paris
- Medici Chapel, Florence
- The Metropolitan Museum of Art, New York
- Sistine Chapel, Vatican, Rome
- http://www.michelangelo.com/buonarroti.html

MARY CASSATT

- The Art Institute of Chicago
- Cleveland Museum of Art
- Dallas Museum of Art
- The Metropolitan Museum of Art, New York
- Musée d'Orsay, Paris
- National Gallery of Art, Washington, D.C.
- Nelson-Atkins Museum of Art, Kansas City
- Philadelphia Museum of Art
- Pushkin Museum, Moscow
- http://watt.emf.net/wm/net

DONATELLO

- Baptistery, Siena
- Bargello, Florence
- Detroit Institute of Arts, Michigan
- Louvre, Paris
- Museo dell' Opera del Duomo, Florence
- Museum of Fine Arts, Boston
- National Gallery of Art, Washington, D.C.
- Saint Peter's, Vatican, Rome
- Santa Maria Gloriosa dei Frari, Venice
- Victoria and Albert Museum, London
- http://www.thais.it/scultura/donatell.html

THOMAS EAKINS

- Brooklyn Museum
- Detroit Institute of Arts, Michigan
- Honolulu Academy of Arts
- Jefferson Medical College, Thomas Jefferson University, Philadelphia
- The Metropolitan Museum of Art, New York
- Nelson-Atkins Museum of Art, Kansas City
- Pennsylvania Academy of the Fine Arts, Philadelphia
- Philadelphia Museum of Art
- Whitney Museum of American Art, New York
- http://www.cab.u-szeged.hu/cjackson/e/index.html

KIKUGAWA EIZAN AND JAPANESE PRINTS IN THE UKIYO-E STYLE

- M. H. de Young Memorial Museum, San Francisco
- Freer Gallery of Art, Smithsonian Institution, Washington, D.C.
- The Japan Ukiyo-e Museum, Matsumoto
- Los Angeles County Museum of Art
- The Metropolitan Museum of Art, New York
- Museum of Fine Arts, Boston
- http://terminus.econ.rochester.edu/UKIYOE/index.html

PAUL GAUGUIN

- Albright-Knox Art Gallery, Buffalo
- The Art Institute of Chicago
- Cleveland Museum of Art
- Courtauld Institute Galleries, London
- The Metropolitan Museum of Art, New York
- Musée d'Orsay, Paris
- Museum of Fine Arts, Boston
- National Gallery of Art, Washington, D.C.
- National Museum, Stockholm
- The Phillips Collection, Washington, D.C.
- Pushkin Museum, Moscow
- Saint Louis Museum of Art
- http://www.mfa.org/special/gauguin.html

WINSLOW HOMER

- Addison Gallery of American Art, Phillips Academy, Andover, Massachusetts
- Amon Carter Museum, Fort Worth
- Brandywine River Museum, Chadds Ford, Pennsylvania
- National Museum of American Art, Smithsonian Institution, Washington, D.C.
- North Carolina Museum of Art, Raleigh
- Pennsylvania Academy of the Fine Arts, Philadelphia
- Wichita Art Museum, Kansas
- http://server oz.boston.com/mfa/homer/mfahomer.htm

CARMEN LOMAS GARZA

- The Hirshhorn Museum and Sculpture Garden, Smithsonian Institution, Washington, D.C.
- McAllen International Museum, McAllen, Texas
- Mexican Fine Arts Center Museum, Chicago
- The Mexican Museum, San Francisco
- Oakland Museum, California
- Texas Women's University, Denton

MARISOL

- Brooks Memorial Art Gallery, Memphis, Tennessee
- Hirshhorn Museum and Sculpture Garden, Smithsonian Institution, Washington, D.C.
- Museo de Arte Contemporaneo, Caracas
- Museum of Modern Art, New York
- Tokushima Modern Art Museum, Japan
- Whitney Museum of American Art, New York

HENRI MATISSE

- Albright-Knox Art Gallery, Buffalo
- The Art Institute of Chicago
- The Hermitage Museum, St. Petersburg, Russia
- The Metropolitan Museum of Art, New York
- Minneapolis Institute of Arts
- Musée Matisse, Nice, France
- Museum of Fine Arts, Boston
- Museum of Modern Art, New York
- Pushkin Museum, Moscow
- Norton Simon Museum, Pasadena, California
- Tate Gallery, London

FAITH RINGGOLD

- Solomon R. Guggenheim Museum, New York
- High Museum, Atlanta
- The Metropolitan Museum of Art, New York
- Museum of Fine Arts, Boston
- Museum of Modern Art, New York
- Newark Museum, New Jersey
- Studio Museum, Harlem, New York
- University Art Museum, University of California, Santa Barbara
- http://www.netnoir.com/spotlight/bhm/quilts.html

JOHN SINGER SARGENT

- Ashmolean Museum, Oxford
- Dallas Museum of Art
- Freer Gallery of Art, Smithsonian Institution, Washington, D.C.
- Charles and Emma Frye Art Museum, Seattle
- The Metropolitan Museum of Art, New York
- Museum of Fine Arts, Boston
- Taft Museum, Cincinnati
- The Tate Gallery, London
- Terra Museum of American Art, Chicago
- http://www.yawp.com/cjackson/sargent/

HENRY OSSAWA TANNER

- The Art Institute of Chicago
- Carnegie Museum of Art, Pittsburgh
- Hampton University Museum, Virginia
- Los Angeles County Museum of Art
- Musée de l'Etat, Luxembourg
- National Museum of American Art, Smithsonian Institution, Washington, D.C.
- Philadelphia Museum of Art
- The White House Collection, Washington, D.C.
- http://blackhistory.eb.com/micro/728/10.html

VINCENT VAN GOGH

- The Art Institute of Chicago
- Barnes Foundation, Merion Station, Pennsylvania
- Dallas Museum of Art
- The John Paul Getty Museum, Santa Monica, California
- Solomon R. Guggenheim Museum, New York
- The Metropolitan Museum of Art, New York
- Museum of Modern Art, New York
- National Gallery of Art, Washington, D.C.
- National Museum Vincent van Gogh, Amsterdam
- Rijksmuseum Kröller-Müller, Otterlo, Netherlands
- http://www.cab.u-szeged.hu/cjackson/gogh/

CREDITS *(listed in order of appearance)*